THE ART of TIME TRAVEL

MOTHER OF FRANKENSTEIN

MARY MOLDS A MONSTER

GENEVA 1816 SWITZERLAND

∞ BY LISA AND JOHN MULLARKEY ∞
ILLUSTRATED BY COURTNEY BERNARD

Calico

An Imprint of Magic Wagon
www.abdopublishing.com

To our own little monsters, Sarah and Matthew: We love you!
—Mom & Dad

www.abdopublishing.com

Published by Magic Wagon, a division of ABDO, PO Box 398166, Minneapolis,
Minnesota 55439. Copyright © 2015 by Abdo Consulting Group, Inc.
International copyrights reserved in all countries. No part of this book may be
reproduced in any form without written permission from the publisher. Calico™
is a trademark and logo of Magic Wagon.

Printed in the United States of America, North Mankato, Minnesota.
102014
012015

 **THIS BOOK CONTAINS
RECYCLED MATERIALS**

Written by Lisa and John Mullarkey
Illustrated by Courtney Bernard
Edited by Tamara L. Britton and Bridget O'Brien
Cover and interior design by Candice Keimig

Library of Congress Cataloging-in-Publication Data

Mullarkey, Lisa, author.
 Mary molds a monster / by Lisa and John Mullarkey ; illustrated by Courtney
Bernard.
 pages cm. -- (The art of time travel)
 Summary: Sixth-grader Maggie is stuck with insufferable Jacob on a class writing
project, and when they get into an argument over who really wrote the novel
Frankenstein, they suddenly find themselves in Switzerland in 1816 where Lord
Byron and Mary and Percy Shelley are planning to write a scary story each--the
trouble is Mary has writer's block.
 ISBN 978-1-62402-088-9
1. Shelley, Mary Wollstonecraft, 1797-1851--Juvenile fiction. 2. Time travel--
Juvenile fiction. 3. Authors, English--19th century--Juvenile fiction. 4. Writer's
block--Juvenile fiction. 5. Geneva, Lake (Switzerland and France)--History--19th
century--Juvenile fiction. 6. Switzerland--History--19th century--Juvenile fiction.
[1. Shelley, Mary Wollstonecraft, 1797-1851--Fiction. 2. Time travel--Fiction.
3. Authors--Fiction. 4. Authorship--Fiction. 5. Geneva, Lake (Switzerland and
France)--History--19th century--Fiction. 6. Switzerland--History--19th century--
Fiction.] I. Mullarkey, John, author. II. Bernard, Courtney, illustrator. III. Title.
 PZ7.M91148Mc 2015
 813.6--dc23

 2014032254

TABLE of CONTENTS

Meet **Mary Shelley**

Mary Shelley created one of the most famous monsters of all time. Since her novel *Frankenstein: Or, the Modern Prometheus* appeared in 1818, it has never gone out of print and has been translated into more than thirty languages. To this day, the book is considered the first great work of science fiction.

Mary Shelley was born on August 30, 1797, in London, England. Her parents were philosopher William Godwin and women's rights advocate Mary Wollstonecraft. Mary's mother died when she was just 11 days old. Mary was educated at home and had access to her father's library. He encouraged her to read and write and expected her to excel in intellectual pursuits.

Those expectations were dashed when, at age 16, Mary fell in love with poet Percy Bysshe Shelley. They would marry on December 30, 1816. In the summer of that year, with Mary's sister Claire, the two traveled to Geneva, Switzerland. There, they stayed with Percy's friend George Gordon, Lord Byron and Byron's physician, Dr. John Polidori.

One night, Lord Byron posed a challenge. Who could write the scariest story? Mary was up to the challenge to prove herself worthy of her father's expectations. But she struggled with writer's block, and her frustration mounted as weeks passed without any progress.

Then, Mary dreamed one night of a young doctor kneeling next to a human-like creation. When she awoke, she was encouraged to write about her dream. On January 1, 1818, 500 copies of *Frankenstein: Or, the Modern Prometheus* were published.

The book was published anonymously. At the time, many believed that a woman was incapable of writing such a blasphemous story. Percy was widely considered to be the author. It wasn't until the second edition was printed five years later that Mary's name appeared on the book.

In 1822, Percy drowned in a boating accident. A widow at the age of 24, Mary settled in England with the couple's last living child, Percy Florence. She died on February 1, 1851. Although Mary Shelley wrote other novels, she will always be remembered for creating *Frankenstein*.

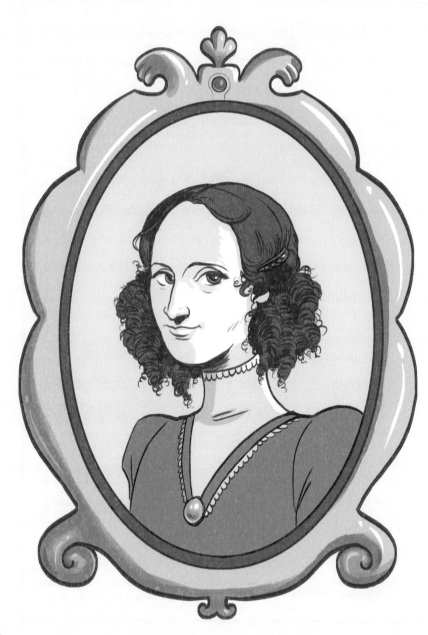

BACK IN TIME

"You're late," I said glancing at my watch.

Jacob shrugged and flung his backpack on the table. "Better late than never. I told you my sailing lesson wouldn't be over by eleven."

Jacob Saville and I took sailing lessons at Bourne Community Boating. We took lessons together last year. But after he barked orders at me one too many times, my parents switched me to private lessons.

"Sh," came a voice from behind us. We turned to see Mrs. Nelson, the librarian, smiling. "The Jonathan Bourne Public Library has rules." She tapped on a poster behind her desk. Rule #2: Use Quiet Voices.

She pointed to a room with glass windows. "Maggie, if you're going to talk, use the study room, please."

I picked up my backpack and laptop and headed across the room.

Jacob grabbed my elbow. "Let's stay here."

I wiggled free. "I don't want to upset Mrs. Nelson. She's helped me with a lot of projects."

He patted my back. "Okay, you're in charge."

Ha! That was a joke. Jacob never let anyone be in charge of anything. When we sailed together, he acted as if he were the captain. When we played kickball at recess, he changed the rules and picked the teams. And last year, when we had class elections, he told everyone who to vote for. And it wasn't for me. I got clobbered. I swore I'd never speak to him again. And I didn't.

Until yesterday.

That's when Mr. Vincent, our science teacher, paired us up for a research project. "I can't work with him," I grumbled.

"That's why I'm partnering you up," said Mr. Vincent. "In the real world, you'll have to work with

all sorts of people. It's important to find ways to compromise and get along."

"But this isn't the real world," I whined. "It's sixth grade."

Jacob waved his hand in the air. "I don't care who I get for a partner. I can deal with a girl."

"*Deal* with a girl?" I asked. "Like a girl is something to deal with?"

Mr. Vincent winced. "Maggie, a percentage of your grade is based on cooperation. You're not off to a good start. Understand?"

I lowered my voice. "Understood. It's just that I have straight As and…"

Mr. Vincent frowned and crossed his arms over his chest.

"Sorry," I whispered.

So today, I'm stuck working with a kid I don't like.

I pushed Mr. Vincent out of my head and decided to focus on keeping my grades up. At least I wasn't still taking sailing lessons with him.

As I got my index cards and highlighters out of my backpack, Jacob sat there doodling in his notebook.

"If you think I'm going to do this entire project by myself, you're wrong," I said.

"Calm down, Margaret."

"Maggie," I said. "It's Maggie. No one calls me Margaret."

He smirked and pulled a book out of his bag. "Mr. Vincent said we can pick any scientist we want to research." He opened the book up and ran his finger down a page. "How about Louis Pasteur or Jonas Salk?" He flipped the page. "Maybe Pavlov? He's the one who experimented with dogs."

"Aren't there any women in that book?" I asked. "What about Madame Curie? Virginia Apgar?"

Jacob lowered his eyes. "Yeah. They're listed in here. I just didn't pick them. Why would I?"

I put my hands on my hips. "Why wouldn't you?"

"Well, you know," he said. "They're girls."

"Women," I said. "And what's wrong with that?"

He slapped his forehead and slowly shook his head. "Oh, no! You're not one of *those* are you?"

"One of who?" I asked.

"You know." He snapped his fingers. "What are they called? We learned about them when we studied the Nineteenth Amendment."

"Suffragettes?" I asked.

"Nah," he said. "It starts with an *F*, I think."

"Feminists?"

"That's it!" he yelled.

I had never thought about it. "A feminist is just a woman who believes that she should be treated the same as a man. Equal rights. Equal pay. So, yeah. I guess I am one of *those*. Don't you think women should be treated as equals?"

He sucked in his breath. "I guess so. I mean, if they do the same work. But . . ."

"But what?"

"Put it this way, I think a woman can do anything that a man can do. But, she wouldn't be as good at it."

I gritted my teeth. "What's that supposed to mean?"

He ignored me and held up his drawing. "Like it?"

"Is that Frankenstein's monster?" I asked.

"Yep!" His eyes lit up. "Have you ever read the book? It's such a cool story."

"Yeah, I read it," I said. "We read it last year in my honors English class."

"Well? Did you like it?"

I nodded. "Our teacher said it was the first science fiction novel ever written. It made me want to watch the movie."

"They had a *Frankenstein* movie marathon last month at the Falmouth Art Center," he said. He picked up his pencil and added another scar to the face. "Everyone thinks that Frankenstein is the name of the monster, but it's really the name of the mad scientist who created him."

"I know," I said. "I read it. Remember?"

"Do you think it's a horror story or science fiction?"

"A little bit of both," I said. "But Gothic describes it the best."

Jacob's mouth fell open. "Really? I can't believe you know so much about it. I thought girls only liked pony and rainbow stories. You know, love, BFFs, and junk like that." Then he snorted as he tugged on the Harry Potter book sticking out of my bag. "Women can write well but men are so much better at it. That's what I meant before. I mean, there's no way a woman could write something like *Frankenstein*, ya know?"

How could he say it's his favorite book when he didn't even know who the author was? It made my blood boil. "Who wrote it?" I demanded.

I couldn't wait to hear his answer.

He shrugged. "Some guy. I forget his name."

I was speechless. *Some guy?* I couldn't wait to see the look on his face when he found out that a woman wrote it.

"I'll be back in a minute." I trudged out to the main part of the library and headed over to the fiction

section. When I found it, I ran my finger across the spine labels looking for Shelley.

Shelby, Shelton, Shumsky. It wasn't there. Didn't every library own a copy of *Frankenstein*?

"Can I help you, dear?" asked Mrs. Nelson.

"Do you have any copies of *Frankenstein*?"

"The copy we have is quite old. We lent it to the film festival last month. When it came back, it needed to be repaired. It can't be checked out until it's patched up."

"Can I just look at it here? We sort of need it for a school project."

"You can get it from the basement." She pointed to a door that read Staff Only. "Just handle it with care. That book has been here for so long, it may have truly belonged to Dr. Frankenstein himself!"

I laughed.

When I got back to the room, Jacob had his feet up on a chair and was paging through an Isaac Asimov story collection. There was a grin on his face.

"Check it out. Every story in here is science fiction and written by Mr. Isaac Asimov himself. Mister Asimov. Get it?"

"Big deal," I said. "Women can write science fiction and horror, too."

"Yeah," he said. "But are the stories any good? And could they ever be as good as *Frankenstein*, ya know?"

"No, I don't know." I had to take a deep breath. "Mrs. Nelson asked us to get her a book from the basement. You have to come with me."

He pushed his chair out and rolled his eyes. "Like I said, you're in charge."

We walked over to the old wooden door that read Staff Only. When I pushed it open, there was a set of concrete steps that led down to the basement. I flicked a switch and a dim light lit up the bottom of the stairs. As we started down, I paused. "Did you hear that? It sounded like thunder."

"Why are girls always so scared?" Jacob asked.

"Who said I was scared?" I shot back.

Once downstairs, I saw rows of bookcases, old card catalogs, and a supply cart stuffed with rolls of tape. I pointed to the cart under the window. A sign taped to the cart's top shelf read Repairs. "That's the cart we need. Mrs. Nelson said the book should be there."

Finally! I was about to get the proof I needed to shut Jacob up for good.

There were a few dozen books on the cart but I saw it right away. Its blue cover was worn and faded. On the front, in gold embossed lettering, was *Frankenstein: Or, The Modern Prometheus* by Mary Wollstonecraft Shelly. I held it out for him to see.

"Here's your all-time favorite book. Notice the name?"

Jacob reached for the book. When he touched it, a thunderous boom filled the air.

"Mary Wollstonecraft Shelly." Then he looked puzzled. "Mary? No way. A woman could never write *Frankenstein*. Is that what you dragged me down

here for?" His voice cracked. "What's your point, Margaret?"

"I told you not to call me that!" I gritted my teeth and clenched my fists as Jacob walked away. "Not only did a woman write *Frankenstein*, but she was only nineteen when she finished writing it! She wrote it when she was a teenager!"

Jacob didn't believe me. He whipped out his phone and Googled her. "It says here that some people think a guy named Percy wrote it."

"Percy and Mary got married. She wrote it while they vacationed in Sweden. Or Switzerland. I can't remember which one. But she wrote it. She didn't sign her name at first because she knew that people would never believe that a woman could write science fiction. She was afraid that if a woman's name were on it, no one would read it. But five years after it was published she agreed to have her name on the cover." I tapped her embossed name. "It's still one of the all-time best-selling books today."

Jacob smirked. "She probably got the idea from that guy. Maybe she cowrote it with him. Back then, women just didn't think this way."

Was he trying to make me mad? Because the more he smirked, the madder I got. I was fed up with Jacob and his views of girls and women. I placed the book back on the cart.

An even louder clap of thunder shook the building. Suddenly a flash of lightning lit up the entire room. The lights flickered off and on before going out for good. I felt woozy. Dizzy. So dizzy, that I fell. Cold wind rushed over us. Then, oddly enough, the sound of birds chirping filled the air.

"What happened?" Jacob moaned. "And who turned the lights out?"

"I don't know," I said. "Maybe the storm knocked them out." But a minute later, a ray of sunshine pierced through the window and flooded the room with light. I made my way over to the window and gasped. Since when did Bourne have mountains like that?

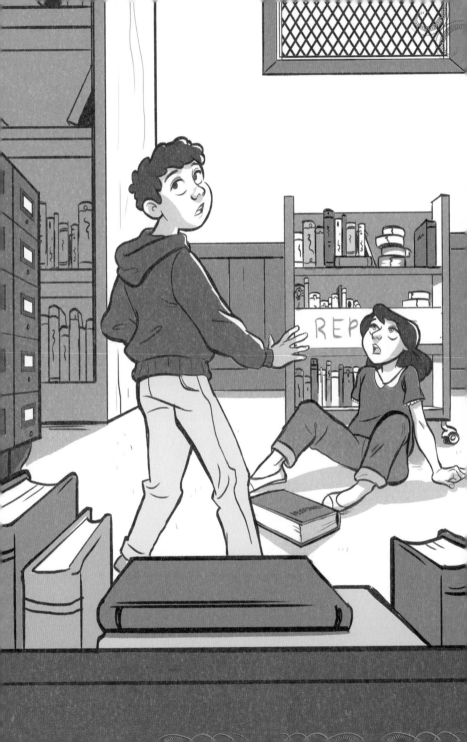

"Um, Jacob. I know this sounds crazy, but I'm pretty sure we're not at the Jonathan Bourne Public Library. I don't even think we're in Massachusetts anymore."

CHAPTER 2

A FLASH OF LIGHT

Jacob quickly stood up and rushed over to me. "What is this place? I don't get it. The books are gone. The cart, the tape, the shelves . . . all gone."

"How could they all vanish like that?" I asked.

"There has to be a logical explanation, doesn't there?" he asked.

I looked around the room. Nothing looked familiar. There were empty racks on the walls and several barrels lined up near the window. Ropes were neatly coiled beside two doors. What looked like an old mast with a canvas sail was rolled up and rested on two large bricks. Wooden planks covered the floor and the room smelled like musty rags and burnt wood.

Jacob pointed to a fireplace with a stack of wood next to it and a few empty wine bottles on the hearth.

"It looks like someone used the fireplace not too long ago."

I chewed on my nail. "This looks like a place to store a boat or where you can have a party if it's too cold to sail."

"A boathouse!" said Jacob.

There was an old wooden table with five chairs hastily arranged around it. High above the table were timbers that crisscrossed and supported the roof. A few small birds flittered back and forth near the highest part of the ceiling. "Look at the birds," I said.

Just then, one swooped down and flew inches above our heads. "They're not birds," screamed Jacob. "They're bats!"

We ran to the doors and pushed them open. Outside, the sun was just beginning to set. We fell into the grass at the edge of a long wooden dock. I turned to look at the building we had just left. It was made of stone and had a slate roof. The single chimney was made of the same stone as the building.

"You were right," I said. "It is a boathouse." I turned back around to check out the dock. It led to a huge, gleaming lake. It was surrounded by sloping green hills and dotted with what looked like mansions and vineyards. Then I pointed toward the snowcapped mountains rising above low clouds. "Aren't they beautiful?"

Jacob scratched his head. "Where are we? This looks like Fantasyland."

Staring at the landscape, I realized where we were. My whole body started to shake and tremble.

Jacob took off his sweatshirt and threw it around my shoulders. "Are you okay?"

I started to cry. "No. I'm scared. I don't think we're even in the United States."

Now Jacob looked nervous. "We have to be. Where else could we be?"

I pointed to the lake. "I'm pretty sure we're looking at Lake Geneva. In Switzerland." Now Jacob freaked out. "Switzerland! How the heck did we get here? Are

you sure?" Sweat poured down his face even though it was cool outside.

"I'm pretty sure. This looks exactly like the pictures from my European geography class last year. These mountains are the Alps."

"How the heck did we get here?" he asked again.

"And how are we going to get home?" I added.

Jacob stood up and helped me to my feet. We stood there for a few minutes without saying anything. The lake stretched out for what looked like forever. Several small sailboats dotted the shoreline. The mountains rose up on both sides of the lake. We spotted houses tucked away here and there. Some looked like mansions and mixed in with the tall trees.

"Breathe the air in," I said. "It will make you feel better. And look how clear the water is! Have you ever seen anything like it?"

Jacob was as white as a ghost. I took a few steps toward the lake and noticed a small sailboat tied up to the right side of the dock. A flag on a long

pole fluttered in the breeze at the end of the dock. "I wonder who that flag belongs to?"

Jacob's eyes lit up. "It's not Switzerland's flag. So maybe we're not in Switzerland."

I pointed to the lake. "I'm pretty sure we are."

We walked out on the long dock. The wind whipped across the lake and birds circled above us. There were sandbags stacked at the end of the dock. A flag on a thin wooden pole flapped in the breeze.

"The flag's really neat looking," said Jacob. "Check out the eagle and the key on it."

"Look at the boat," I said.

"Looks like an old cat boat or small sandbagger," said Jacob. "We can sail it. It looks about sixteen feet. Check out the hull." He ran his fingers across it. "I like the wooden design. No fiberglass at all." He stepped onto the boat and inspected it closer. "That beam is pretty sturdy and the sail looks heavy. Do you think its gaff rigged?" He turned to face me. "There must be some pretty heavy winds on this lake!"

"They might use the sandbags for ballast," I said.

"Do you think there's enough to stop it from tipping?"

"Should be," I said. "Someone must have used this recently." I pointed to the picnic basket on the seat.

"And whoever sailed, mustn't be too bright," said Jacob. "They sailed without life vests aboard."

I put Jacob's sweatshirt on.

Just then, a woman's soft voice with an English accent added, "It is also known as Lake Leman."

Jacob and I jumped. We weren't expecting to hear a voice.

We turned around to see a young woman wearing a green coat over a long green dress with a high collar. She had a nice smile but her complexion was pale. Light brown curls draped down her back. She had on a black suede brimmed hat with ribbons and flowers tied around it. It looked like something a pilgrim would wear.

"I didn't mean to frighten you so. Please forgive

me." She extended a gloved hand. "I'm so glad you've arrived. Although I'm a bit surprised. You're a week early. Are you Americans always so eager?" She looked us up and down and stared at our clothes. "What interesting attire you wear. Bold for sure."

We had on jeans and sneakers. Jacob had on a red shirt and I had his hooded gray sweatshirt pulled over my shirt.

We quickly shook her hand.

"I apologize but I've forgotten your names," she said. "I'm Mary."

"I'm Jacob Saville. This is Margaret Johnson." He let out a small laugh.

"Jacob! Margaret! So pleased to meet you."

As she leaned over to pick wildflowers, I kicked him. "Margaret? Really?"

"Where are your sailing clothes?" She looked around the dock. "Your belongings?"

I didn't know what to say. Jacob's mouth dropped open. How was I going to answer her questions?

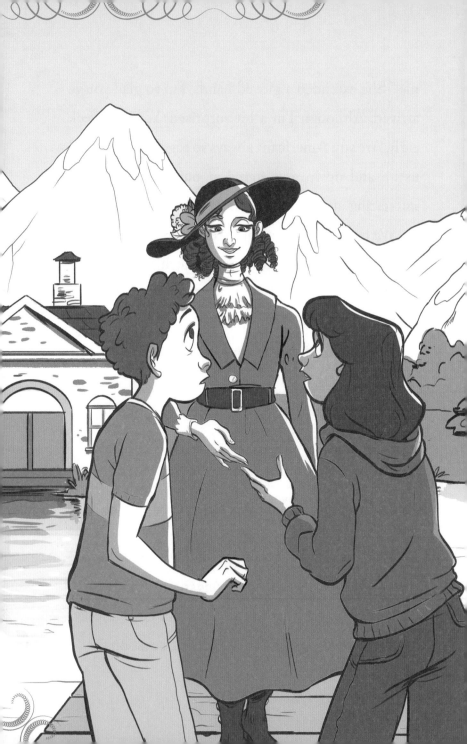

Mary laughed. "You must be terribly tired after your long journey. This is your first trip to Switzerland, yes?"

We both nodded.

"I am sure the journey was difficult. Our weather has been strange this summer. Are you finding it a bit odd in America as well?" She tilted her head as if waiting for an answer.

I stumbled for words. "Our weather is—has been—fine. Last year, it was a little different."

She smiled. "Ah, last year? The summer of 1815 was beautiful in England. But a year later, I'm here in Switzerland with these strange storms. Perhaps it's good you have arrived early to teach me your sailing ways. There will be more time to allow for the change to favorable weather."

So this was the summer of 1816? In Switzerland? I reached for Jacob's hand and squeezed it. His eyes caught mine and both of our eyes started to tear up. I couldn't believe what was happening.

Mary glanced around the dock. "Now don't forget. I paid your way here because you are known by my friends in America as being the best sailor of your kind."

Jacob stepped forward. "Thank you. I'll do my best to teach you."

Mary squawked. "Not you, silly. The girl. What was your name again? Ah, Margaret, correct?"

I smiled at Jacob. "Correct. I'm honored to teach you to sail."

"When I heard you were an expert sailor and a girl, I was more than delighted. I'm of a firm belief that females are just as capable to sail as men. And to think, a lady teacher! And I do so want to learn to sail." She leaned in close to us and spoke in a harsh way. "But the men must never know you're teaching me to sail. They think you are American friends that have come for a visit. And we must keep it that way. Is that understood?" She chewed on her lip. "Where's your father? Wasn't he traveling with you?"

Jacob's eyes grew wide. "Oh, we're not broth . . ."

I spoke over him. "We're cousins. My uncle, Jacob's father, isn't feeling well. He's somewhere . . ." I pointed to the Alps. "Out there. Resting."

Mary looked horrified. "He doesn't have Cholera does he? I have a young child here, my son William. We cannot welcome any ailment here. He is quite fragile."

"No," I added quickly. "He . . . he . . . broke his leg on our journey."

"Oh, that's a pity," said Mary. "Where are your trunks?"

"They were stolen," said Jacob thinking fast. "All of them."

She moved closer to me. "My sister, Claire, is just your size." Then she turned to Jacob. "I suppose between Percy and Lord Byron, we'll manage just fine for you, too."

With that, she turned and walked up a small hill.

"Did she just say Percy?" I asked.

Jacob nodded.

"And Lord Byron?" I added.

He nodded again.

"Jacob! I know who she is! I can't believe it!"

He put his hands on his hips. "Come on, spit it out."

"It's Mary Shelley! The author of *Frankenstein*."

THE CHALLENGE

"Are you sure?" Jacob asked.

"Trust me," I said. "It's her."

Jacob walked without talking. I think he was trying to decide if he believed me.

As Mary walked up the path, she motioned for us to follow. We stayed a few steps behind her so we could try to figure this whole mess out. How could we be in the Jonathan Bourne Public Library one minute and in Switzerland with Mary Shelley the next?

"Are you sure it's her? I mean, how can you be *positive?*"

"Mary. Percy. Lord Byron. Of course it's her. Them. We argued about Frankenstein. Maybe we're here so she can prove to you that she really did write *Frankenstein.* Or ..."

"Or what?" he asked.

"In every time travel book I've ever read, people are always sent back in time to make something right or to make sure someone makes the right choices in their life. Maybe we're here to help Mary. Or Percy. Or perhaps Lord Byron."

Jacob scrunched his nose. "So we traveled back in time just so we could help people we don't know? If it's true, then how are we going to get back home? What if we're stuck here forever?"

I wondered the same thing. "Listen," I said. "Whenever people go back in time in books, they always get back home. Always." I crossed my fingers. "We'll get back, too. I'm just not sure how yet."

We passed through a vineyard that was surrounded by trimmed hedges, low fences, and craggy stone walls and followed Mary through a clearing to a house. A mansion!

Looking out in the distance, I spotted worn trails and dusty roads zigzagging down from villages and

leading straight to the lake. There were dozens of small stone and wooden docks that jutted out into the blue water.

"As beautiful as it is, I don't want to stay here forever," I said.

Mary overheard. "I suppose I would long for my home, too. You're only to be away from America for a month. Surely you will miss your country but the promise of home shall get you through the yearning. I promise the pay will be well worth it. And the view of the Alps will inspire you and should lighten your heart. That is, if you have a heavy one."

"A month?" whispered Jacob. "My dad's birthday is next week. Baseball starts soon." Then he choked up. "My mom is supposed to have her baby any day now."

I didn't have time to console him. Mary was waiting for us at the villa's steps.

"Welcome to Villa Diodati," said Mary. "This is where Lord Byron and Dr. Polidori stay. We gather

here each evening and partake in the most fascinating conversations and debates. My villa, Maison Chapuis, is through the vineyard." She pointed in the opposite direction. "It's only a ten minute walk. If we're lucky, the moon guides us back each evening."

Lord Byron's home was beautiful. It was painted a pale yellow and had red shutters and a red-tiled roof. It was partially hidden by some tall trees.

"Lord Byron likes to sit up on that balcony. It has a great view of both the lake and the walled city of Geneva. I suppose he gets lost in his thoughts up there. He chose this house for its privacy."

"Look at the peacock," said Jacob.

"Lord Byron has many animals," said Mary. "He sometimes treats them better than he treats us."

We climbed the steps and Mary opened the door. When we stepped inside, we were in a kitchen.

"This is the servant's kitchen," said Mary. "Hilda, Margaret and Jacob will need clothes and beds prepared for them at Maison Chapuis."

Hilda nodded and clapped her hands two times which started a frenzy of activity among the servants. "I shall send one of the maids over to prepare them immediately," Hilda replied.

Mary led us up some stairs and into a large room.

"It's beautiful," I said to no one in particular.

"Why thank you. I have taken quite a liking to it myself," said a man seated on a white metal wire-framed chair with a high-arching back. It made him look like a king! He had mysterious dark eyes and hair longer than mine. He wore a white silk shirt with a long purple robe with golden tassels on the sleeves. On his lap was a small poodle and he was gently stroking its head.

Within a split second, a servant rushed over to lift the dog from his lap.

When Mary introduced us to Lord Byron, his eyes widened. He jumped up from his chair and bowed. "Ah! Americans! I am a great admirer of Dr. Franklin and George Washington! The wars are over now and

I feel that England and America will quickly see eye to eye and strike up a grand friendship once more. I hope to meet President Madison when his term ends later this year." He rubbed his hands together. "How I envied Lewis and Clark. News of their expeditions and interactions with Indians was fascinating. Simply fascinating." He motioned for us to sit. "And who are you and your friend here?"

"I'm Mag ... Margaret Johnson. This is my cousin, Jacob Saville."

Mary interrupted. "Cousins. Father's friends. They've arrived early. Hilda is preparing clothes and beds for them at Maison Chapuis."

Lord Byron smiled. "Percy will be delighted. Now he will have others to share his viewpoints with." He sat back down and the poodle was promptly placed back on his lap. "Very good! I shall look forward to our many conversations."

As I smiled at him, Jacob bowed.

I tried not to giggle.

"Follow me to the study," said Mary. "My son William is sleeping but I can introduce you to his father, Percy."

It looked like a library to me. Books lined the walls from the floor to ceiling. A servant stood on a ladder shelving a few worn copies.

A man sat on a bench near a round table that was covered with paper. His eyes looked sleepy as he stared out over the lake. His wavy hair reached to his shoulders. He couldn't have been much older than us.

He stood when Mary spoke and straightened his long, red jacket.

"Percy, may I present Margaret and Jacob? Cousins. My American friends. Jacob's father has taken ill so they shall stay with us for a few weeks."

"It shall be with great pleasure," said Percy. "But I must warn you. We are a rowdy bunch. I do hope it doesn't frighten you away. But it's all in good fun and jest, isn't it Mary?"

Jacob bowed again.

Before we had time to speak, two servants whisked us away to a small room where we changed.

There were so many clothes to put on! Way too many buttons! After I stuffed myself into them, I looked in the mirror and cringed. I looked ridiculous in such an ornate dress.

When Jacob saw me, he laughed. "It looks like a Halloween costume."

Mary greeted us again. "I hope the clothes suit you. We shall provide you with fresh ones daily until you have time to purchase material." She led us across shiny wooden floors and fancy carpets through a maze of rooms.

"This is the salon," said Mary as she rearranged some flowers in a vase. "We spend a good portion of each evening in here telling ghost stories and fantastic tales. Do you like ghost stories?"

"I love them," said Jacob.

I nodded. "Me, too."

Mary clapped her hands together. "What fun!

More storytellers in our midst. The others will be pleased." She rang a bell. "We've already eaten our dinner but Hilda will fetch you yours. I'll be back after you've had your fill." And then she dashed off again.

"So *that's* the great Mary Shelley?" asked Jacob when we were finally alone. "Are you sure she wrote *Frankenstein*? She doesn't seem creepy enough. I figured someone with a warped mind would have written that."

"The one and only," I said trying to loosen my stiff collar. "So this is a salon? I guess it's a fancy word for living room."

And it sure was fancy! The floors were covered with beautiful carpets that looked like tapestries. The room was filled with large blue velvet couches with gold trim. They were arranged in front of a huge fireplace so that they faced each other. There were long tables in the center of the room. Candelabras arranged around the room held dozens of candles.

"My living room doesn't look like this in Massachusetts," said Jacob. "I feel like we're in a museum."

I had to blink hard so I didn't cry when he mentioned home.

When our dinner arrived, two servants lit every candle in the room. It took them twenty minutes! After eating fruit, cheese, and some sort of roasted meat, we sat down by the windows.

"Look at the view," I said. The windows and shutters were open so a cool breeze blew in from the lake. It was getting dark.

Percy, Lord Byron, Mary, and two other people soon joined us.

It was all so strange. Here we were in 1816 in Switzerland with some of the greatest writers and thinkers in the English language! I quickly yanked Jacob aside.

"Go along with whatever they say. We're not in any danger, and, who knows, we could end up back

home in Bourne at any moment. Whatever you do though, don't mention anything that's happened in the present. Nothing you learned in history. I have this feeling that if we tell them about things that have happened . . ."

"Like the Civil War and landing on the moon?" asked Jacob.

"Exactly," I said. "Not to mention things like photography, movies, and even modern medicine. If we do, we might mess up the thread of time and be stuck here forever!"

Mary came over and took us both by the hand. She guided us to the fireplace where one of the servants stoked the flames. The other servants rushed around closing windows.

"Master Byron," said Hilda. "It looks like a tempest is blowing down through the mountains. Alas, another storm. The thunder might be loud but the shutters are secure. Extra logs are by the fire and tea and cider are on the table."

A devilish smile came across Lord Byron's face. "Brilliant! Just a bit of the gods making a calling on us and letting us know that they want to be a part of our little gathering!" He waved us over. "Please come over young Margaret and Jacob. We have introductions to make!"

The fire glowed as Jacob and I approached the others.

Percy moved over on the couch to make room for us. There was a young man with slicked back black hair on the other end. He stood.

"This is the grand Dr. Polidori," Lord Byron said. "He is a physician and a fine storyteller."

The man smiled. "Very nice of you to visit."

"How do you do?" said Jacob.

"I'd be a lot better if I could get my wound to heal. Whoever heard of a doctor not being able to cure his own ills?"

Mary put her nose in the air. "I told you that Hilda could cure you. Just give her a chance."

Percy steered Mary away. "Good heavens, give the good man a break from your interference."

I thought Mary would be angry but she laughed. Everyone did. So Jacob and I joined in.

There was another woman seated on the opposite couch. She had a dress on that was similar to Mary's but it was much more colorful.

"This, my friends, is my sister, Claire Clairmont," said Mary.

Claire ignored us and batted her eyelashes at Lord Byron.

He turned away from her.

As he did, thunder rumbled and shutters rattled.

Lord Byron peeked outside. "Yes, my American friends! We've been spending these stormy nights reading and telling stories to stir our souls and imagination. We welcome all thoughts on science, politics, and philosophy here."

Percy nodded. "The news from Europe and around the world has allowed my poems to flow freely. My

pen has rarely left the paper. Why the advancements in science alone fill my thoughts. Our dear friend, Dr. Polidori, has told us of the uses of electricity in medicine. Can you imagine?"

Just then, lightning flashed and thunder rocked the house. The candles flickered and the walls shook. Lord Byron rushed over to the fireplace. He grabbed a candle and held it under his chin. The flickering flame cast an eerie glow upon his face. Claire seemed to be even more fixated on him. Her eyes never moved away from him.

"A storm rages tonight," he said. "We have all been moved by nature's power. Our new friends must have tales to tell from across the Atlantic. Let's welcome both Margaret and Jacob with a scary story."

For the next hour, Jacob and I listened to story after story. Some were scary, some bizarre, and most left me confused. But Jacob and I were good listeners. If they laughed, we laughed. If they acted frightened, we did too. It felt like a game.

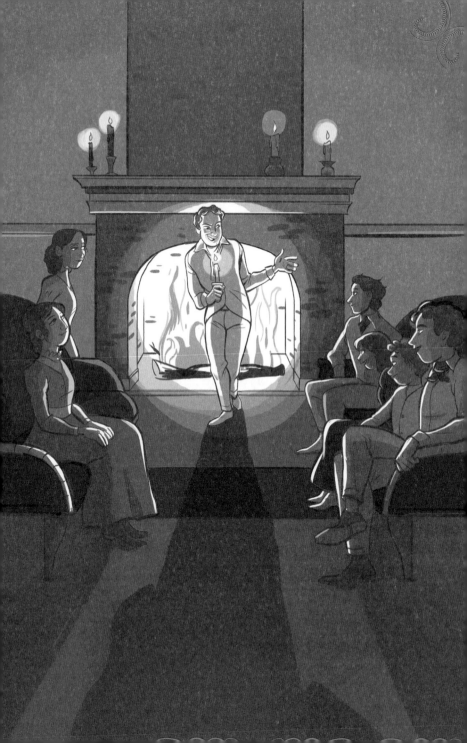

"Does anyone want to tell another?" asked Lord Byron.

"I'm afraid I'm running out of stories," said Mary. "I do not want to repeat myself."

"Ah, Mary. You have given me an idea! As we gather here by this crackling fire safe from the raging storm outside, I shall offer each of you a grand challenge. Devise a story. A story of monsters and ghosts to terrify our new friends and make their blood boil. Stories that shall haunt our every breath."

This excited everyone in the room except for Jacob and me. Unless the challenge was to find a way to get us back to Massachusetts, we didn't want to hear about it.

A SAILING LESSON

"How did you sleep?" asked Percy the next morning.

I faked a smile and lied. "Fine, thank you."

But I had barely slept at all. After we left Villa Diodati, we trudged through the vineyards to get back to Maison Chapuis. Once we had arrived, Mary insisted on showing us around the house. It was much cozier than Villa Diodati but it was still large. Although exhausted, I was too worried thinking about how Jacob and I were getting back home to sleep.

Mary came into the kitchen holding a baby. "This is William. He's a bit ornery today."

William kicked and cooed. He blew raspberries at Percy then began to chew on his fist.

Mary quickly handed the baby off to a servant and turned to Percy. "I'm taking our guests to see Jacob's father. I've instructed the servants that you are not to be disturbed unless the world is about to end."

Percy pecked Mary on the cheek. "It will end if I don't pen my latest poem today." His face brightened. "Did you write your grand story for Lord Byron last night? I saw the candles flickering under the door. You spent endless hours in the study. Lord Byron will be pleased."

Mary sighed. "I have no story. My mind was empty of all thoughts. At least those pertaining to the challenge." She put her head down briefly on the table. "I fear I will never be able to meet your expectations. Or Lord Byron's. Did you write a story? What will you share tonight?"

Percy frowned. "Nothing exciting. Certainly nothing worthy to share with Lord Byron."

"But you did put pen to paper?" asked Mary. "You wrote *something*?"

When Percy nodded, Mary's eyes filled with tears. "My mind is a vast drought."

"There now. Tonight you shall weave your tale," said Percy. "Don't despair. Perhaps Lord Byron or Dr. Polidori haven't written anything either."

When Percy excused himself, Mary's eyes brightened. "I need to clear my mind of absent words. Are you ready to teach me to sail?" She peeked out the window. "The sky is blue. But who knows how the weather will be later today? If we go now, we will have a few hours before the others set sail. I am certain of that."

Twenty minutes later, we were at the boathouse. Jacob didn't say much and every time Mary asked me a question about sailing, Jacob rolled his eyes.

Mary cocked her head. "Jacob, why does it bother you that Margaret is delivering the instruction today?"

Jacob shrugged. "Back in America, I navigated around all kinds of waterways. I'd love to take this boat for a ride and show you how to sail through the

winds. I'm an accomplished sailor. I've won trophies and awards, you know."

Jacob stepped in front of me. "I'd be a good teacher, too." He talked a mile a minute about his sailing exploits back home on Buzzard's Bay.

Mary smiled but raised her gloved hand and cut him off midsentence. "I think your skills appropriate and quite wonderful, Jacob. But what of Margaret? I am sure that she has talents and skills to share. Yes? That is why I was with the understanding that Margaret was to deliver my lessons. At least that's what I was told when I inquired about the best sailor in America nearest to my age. I was told of a girl. Margaret. Now here she is. To disregard her would be a disservice to women. You see, my mother, Mary Wollstonecraft, believed in the progress of women to perform jobs and achievements quite equally with their male counterparts."

She scanned the area. "Remember, my friends, we shall not talk about my sailing excursions in the

company of Byron and Percy. It is intended as a surprise."

Jacob's mouth hung open. I could hardly believe that the author of his favorite novel had put him in his place.

"Uh, sure thing. Margaret knows how to sail too. I guess."

I rescued Jacob from embarrassment. "We can work as a team but we need to go over some basics first."

The three of us walked over to the dock. Jacob leaned in and loosened the rope.

Just then, the sun came out from behind the clouds and a brisk breeze picked up off the lake. The Alps towered in the distance. It looked like a postcard.

"So Margaret," said Mary. "What does a sailboat captain need to know?"

I hopped inside the boat which was not easy thanks to my dress. Mary reached out her hand and I helped her settle down into a seat in the stern.

"Do you know that you are sitting in the back of the boat? It's known as the stern," I said. "The front is the bow. Port is left and starboard is the right side."

Mary repeated all four positions.

Jacob climbed down and pushed us away from the dock. We started to drift. He sat down in the center of the boat and used oars to paddle out past the docks.

"Rule number one about sailing is to always be on the lookout for other boats," I said. "Rule number two is to maintain a safe speed so you can control your boat. It's also important to know the features of the body of water that you're sailing on."

"Do you know the lake's features? The depth? Are there any currents or rocky areas?" I asked.

"Oh dear, I don't know," Mary said.

Jacob stood up and pointed to the boom. "We can open the sail now."

The wind wasn't too strong so we didn't let the sail open all the way. The sail took in the breeze and we darted out into the lake.

"Magnificent!" Mary said. "Do continue!"

"The next thing to do is a simple sailing maneuver called tacking. Basically, we're adjusting the boom with the open sail to go through the wind and let the wind move the boat forward. If another boat approaches, we would keep to the right and pass them port-to-port."

Jacob peered out across the lake. "All clear!" He leaned over the side. "I wonder how deep this lake is? It's so clear. And blue."

"As blue as young William's eyes," said Mary. She took her hat off and let the wind blow through her hair.

"Can you swim?" I asked.

"Oh yes, I can swim quite well. But I do not think Percy can swim at all."

"There aren't any life jackets on board," said Jacob. "It's dangerous to sail without them. Maybe we should stay closer to the shoreline just in case the wind knocks us over."

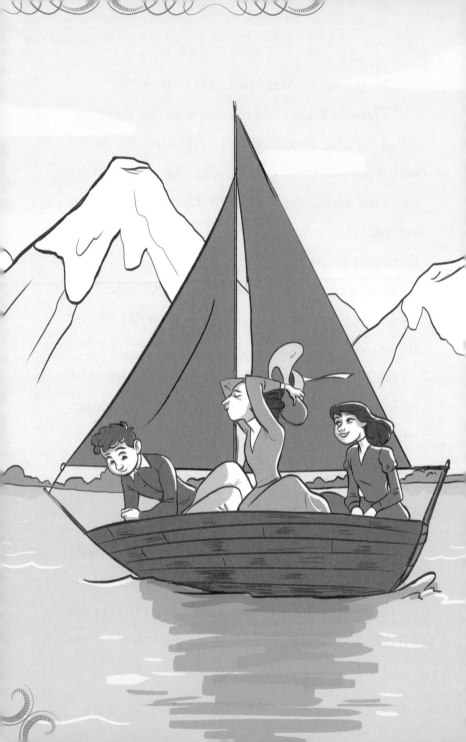

Mary proved to be a fast learner. She moved the boom quickly when needed and adjusted the sail to the level of the wind. And when a sailboat approached our starboard side, she yielded the right of way.

"Well done, Margaret. Jacob, too. I have learned a great deal and will study the water levels here. I am so looking forward to sailing again. I feel that I'll soon be able to show off my new skills."

I hoped we'd be back in Massachusetts before then. Geneva was beautiful, but I missed Bourne.

When we returned to shore, Mary took us on a walk through a wooded area near the lake. She wanted to talk about sailing but I was dying to hear about her writing career. "Aren't your parents famous writers?"

"Why, yes! Mother's writings caused her some difficulty with many critics and politicians due to her beliefs." She frowned. "I never met her. She died when I was but eleven days of age. But I shall show you both a picture of her when we get back to the villa." Her pace quickened. "My father, William

Godwin, continues to write and inspire people to be free thinkers. He has many admirers."

She walked in silence for a few more minutes.

"But I now have a confession to make. Something has been weighing on my heart and I am afraid I must unburden myself onto you both."

"That's okay," said Jacob. "You can talk to us."

"Many people expect a great deal of me and my pen. But I can no longer think of a story to tell. I am considering giving it up altogether. Perhaps it is not my calling after all. My mother, as well as my father, loved the idea of democracy. But it is my mother who inspired me to believe that a woman can be an equal to males in every category. But when I see what the others are writing, I fear I will one day let my mother's memory down. In my heart, I know I am their equal. But on paper, I have no proof."

"Aren't you being a little dramatic?" said Jacob. "And I guess I'm outnumbered here with the whole women are equal to men thing."

Mary and I stopped walking.

"How rude, Jacob," I said.

"Sorry, Mary," said Jacob. "But I know you are a good writer. Why are you ready to throw in the towel just because you're having a dry spell?"

Mary looked puzzled. "Americans have such odd sayings." But the slight smile on her face proved she understood.

Mary walked between us and took our arms. "Ah, my dear young Jacob. Do you feel that women are too excitable and emotional to be on equal ground as men in our society?"

"Well," said Jacob pausing for a minute. "Back home, the girls get all frantic over little things. One minute, they're happy, and then the next, they're sad. It's kind of embarrassing, don't you think? How can girls and women make big decisions in business for example without freaking out when things go wrong? My father would never put up with that. He would say things like 'Take it like a man!'"

"Freaking out?" asked Mary. "How peculiar a phrase, Jacob."

We walked in silence for a minute before she spoke again. "Oh, but Jacob. Is not a family like a business? What if the father is away or too ill to make those *decisions* you speak of?" The mother steps in and takes over. So, if this is true in a family, then why not also in a place of business or better yet, politics? You Americans love freedom and democracy. Who is to say that a woman cannot run for your congress? Or leaders and mayors of communities? One day, you may even have a woman president. My parents would believe so!"

"Even your father?" Jacob said.

Mary chuckled. "I am certain that my father, the famous thinker and believer in free will, William Godwin, would certainly think so. After all, he married a bold and forward-thinking woman. My mother would be proud in my choice of Percy since he thinks I am quite capable of ruling the world."

"That's because he's in love with you," I said.

"Matters of the heart should have nothing to do with sensibilities, Margaret. Percy would rather see the best person for the job, be it man or woman, then choose a man simply because he is one. I cannot speak for Lord Byron but I do know he is far more open-minded than most. Dr. Polidori says he believes in equality but he has a stubborn wound that even he cannot cure. Hilda has a treatment that she says will end his misery but he won't even consider speaking about it with her simply because she is a woman. So, he is a study in contradictions."

We walked without talking for a few minutes before Mary spoke again. "Would you want a man to educate you if there were a woman who was far wiser in worldly affairs? I would not. No more than I would want a woman to do the same if there were a wiser man."

Jacob breathed deeply. "That makes sense. I didn't really think of it that way."

"Splendid! Then I have done my job! My father would be proud that I have asked you to ponder a bit the role of women in our society. I cannot say if the views in your country are more progressive than the ones in Europe, but I do know that the movement advances at a snail's pace here."

"But at least it moves, Mary." I said. "And you're part of that reason."

I wanted to tell her that even two hundred years later, there were still people who believed that a man's work was *always* better than a woman's.

But I bit my tongue.

A TERRIBLE ACCIDENT

We walked for another hour before the air cooled and the sky grew cloudy. A gust of wind blew Mary's hat from her head and trees swayed more than usual.

"Oh dear, this summer has really been rather cold and rainy," Mary said. "Shall we continue on to the lake? I believe Percy, Lord Byron, Claire, and Dr. Polidori are gathering by the docks. They so hoped to take the boat out today."

"I don't know if that's a good idea right now," said Jacob. "Look at that sky. There could be a big storm brewing. The fog's rolling in."

A minute later, we heard a faint noise.

"Is that someone yelling?" I asked.

"Perhaps it's a wild animal," said Mary.

Jacob pointed to the lake. "No, it's out there. But with the fog, it's hard to see who it is."

A minute later, we saw a boat rowing toward us. Someone shouted, "Help us! We are in dire straits!"

"That is Percy!" cried Mary. "He is in danger."

We ran down the embankment and watched the boat approach. "I see Percy and Lord Byron. Claire, too. But where is ..."

That's when I heard them clearly. "Man overboard!"

Jacob ran into the lake and pulled the boat ashore. Lord Byron and Percy looked grim. Claire sat with her cheeks in her hands and terror in her eyes. I followed her gaze only to see the lifeless body of Dr. Polidori.

"He's dead," said Percy. "Drowned by the very waters that have brought us such joy. A gust of wind knocked him overboard. Lord Byron had trouble finding him under the water."

Lord Byron shook his head. "If only I could have brought him up sooner. The water was deep. So very

deep. He must have hit his head when he went over because he never came up to the surface." He placed his hand on his heart. "He has been there for me in my time of need. Many times he has rescued me from my various maladies and ill tempers. He asked nothing in return. If only I had the trident of Poseidon to reach into the depths and draw him out! The fault lies with me." He wiped a tear from his eye. "I shall arrange for the solemn proceedings."

Claire screamed. Then, she rocked back and forth and prayed.

Mary gasped. "Dead!"

The men lifted Dr. Polidori out of the boat and gently placed him on the grass.

"It has only been mere minutes but yet I feel that he has been gone forever," said Percy.

"Wait," I said. "How long ago did this happen?" I rushed over to Dr. Polidori and grabbed his wrist to feel for a pulse. His skin was wet and clammy but not yet cold.

So this is what death looks like, a face as white as the moon, I thought. But as I sat there feeling sorry for poor Dr. Polidori, I felt it. It was faint and irregular, but his pulse was there.

Jacob looked scared and nervous. "Margaret! You took the CPR course didn't you?"

I jumped into action. I bent down and tilted Dr. Polidori's head back and lifted his chin up. Then I opened his mouth and checked his airway. "Pray," I yelled as I pinched his nose. I exhaled and placed the heel of my hand on his forehead, took a deep breath, and exhaled into his mouth.

I heard a commotion all around me. Mary gasped. Lord Byron cried out, "Thunder of Zeus!" and Percy knelt down next to me.

No matter how many times I breathed into his mouth, he lay motionless. I continued with the breaths and then moved to chest compressions. Thirty compressions, two breaths. Thirty compressions, two breaths. My arms ached and sweat ran down my face.

"Can you hear me?" I yelled.

No answer.

Thirty compressions, two breaths.

Thirty compressions, two breaths.

"Can you hear me?" I repeated.

"Let him rest in peace," said Claire. "What are you doing? You stupid wretched . . ."

Then to my surprise and relief, the doctor's eyes opened and his arms shook. He coughed and gurgled as water ran from his mouth. Then he gasped for breath until his breathing became steady.

"Great God! He's alive," shouted Percy. "He's alive!"

Lord Byron fell to the ground. "If I didn't see it with my mortal eyes, I would not have believed it."

Jacob high fived me. "Way to go, Maggie! I mean, Margaret!"

Mary knelt down and took my hands in hers. "Marvelous, Margaret!" she said, "Marvelous! The touch of your hands brought life back to a dead man."

And with those words, Claire fainted.

Jacob, Lord Byron, and Percy carried Dr. Polidori back to Villa Diodati. He said he felt well enough to walk the distance, but Mary wouldn't hear of it.

"You have seen death. You stared it down and have won this time. I am afraid if you exert yourself, your suffering could turn worse. We shall go to the house and send one of the servants into Geneva to beckon a doctor to provide for your care."

As we walked back to the villa, my hands still shook.

"How does it feel to be a hero?" said Jacob.

"I'm just glad I could help," I said.

Mary looked perplexed. "Where did you learn such methods of reanimation? You brought him back to life. Is that what Americans are being taught?"

"He wasn't really dead," I said. "We just needed to get air into his lungs."

"Don't believe her," said Jacob. "We all saw what happened. He was dead. Deader than a doornail. Face

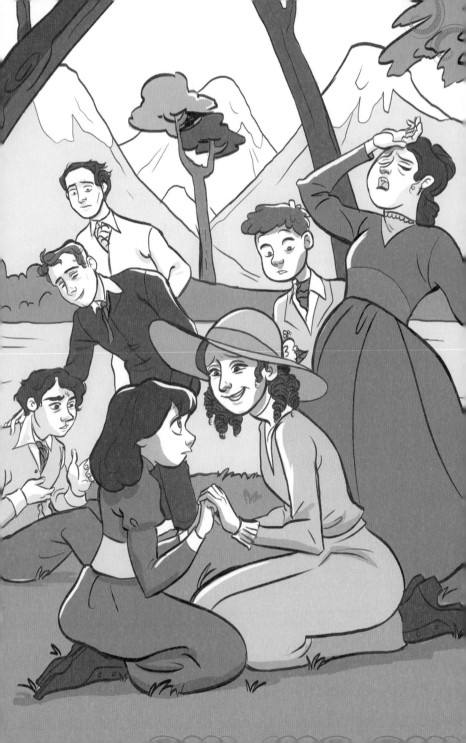

it Margaret, you're a hero. Good thing you were here."
He shot me a look.

Mary grinned. "I have much to learn from you
Americans. Deader than a doornail? I shall remember
to use those odd words myself one day."

By the time we got Dr. Polidori back to Lord
Byron's house and settled, it was time for dinner.

"Although the good doctor would like to join us,
I told him we forbid it," said Mary. "He needs rest
and peaceful thoughts. I do not want him troubled by
scary tales or adventures tonight."

"It may do him good," said Percy. "A tale is always
good for the soul."

"I prohibit it," said Mary. "One tale would lead
to two. Two would lead to four. Four would lead
to many, many more." She rang a bell and Hilda
appeared almost at once. "Take tea up to the good
doctor. Please see to it that he has extra blankets."

That evening after dinner, Lord Byron raised his
glass. "To Margaret!"

Everyone chimed in, "To Margaret! Here, here!"

While Dr. Polidori seemed okay, I wasn't. There was too much happening and I had no control over it. I missed my family. School. Friends. While all this was exciting in its own way, I was terrified I'd be stuck in 1816 forever. Just how were we going to get home?

The weather that evening was dreadful once again. It was dark outside and rain battered the windows. Lightning crackled through the sky and for a brief second, the mountains and lake were ghoulishly lit by wild flashes of white and purple light. The thunderclaps shook the house and made my heart pound.

Mary sat off to our left in a frilly long white dress. Her hair was tied up. Claire had on a similar dress but unlike Mary who spoke to everyone, Claire directed all of her conversations to Lord Byron.

"Margaret? Jacob?" Mary said. "Do either of you have a tale to share? We could use a diversion of the day's events."

Percy added, "Perhaps an American ghost story? Maybe a folktale from Indian lore?"

"We learned mythology in school," Jacob said.

I crossed my fingers that he wouldn't mention anything that hasn't happened yet.

Jacob started off with a low voice. "I remember the story of someone who stole fire from the gods."

"Prometheus!" I added.

Mary's eyes lit up. "The Titan god of forethought. As a little girl, my father read that to me. Please continue!"

"Yes, please refresh our imaginations with that timeless tale," Percy said.

Jacob stared at me as thunder roared outside. I nudged him with my elbow to continue.

His voice became stronger. More confident. "Prometheus was a Titan. The god of forethought. He was given the job of making man out of clay but with rules set by the gods. Prometheus created mankind and was happy with his creation but he wanted more.

His creations needed food. So he broke the rules and went to Mount Olympus and stole the best cut of meat from the gods' feast and gave it to mankind."

I was surprised to see everyone listening so intently.

Jacob continued. "Mankind needed light and warmth so he also stole fire from Zeus and gave it to man. The gods were enraged. As punishment, they created Pandora knowing she would open a forbidden box and unleash misfortune and misery to mankind. Prometheus himself was horribly punished for his deeds by being chained to a mountain for eternity. Each day, an eagle would tear out and eat his liver. The liver would regrow and the following day the eagle would eat it again."

Then I added, "Eventually, after suffering for so many years, Heracles heroically rescued Prometheus but the damage was done. The lesson was learned. Mankind should never try to cheat the gods and the natural world again."

Just then, a huge bolt of lightning slashed across the sky and lit up the entire room. It was followed by the loudest crash of thunder yet.

Claire screamed.

Lord Byron ran to the window. "Aghast!" he yelled. "Was the house struck? Could an electric charge encourage yet more tales of wonder?"

Unless that tale was about two kids returning to Massachusetts, I didn't want to hear it.

AN ADVENTURE

"I can't eat," said Jacob at breakfast. "My stomach hurts."

I plucked a bunch of grapes from his plate. "Eat. I don't want them to think we're rude."

"I want to go home. When are we going?" He put his head down on the table. "How are we ever going to get back?"

"I don't know," I said. "But we'll figure it out soon. I mean, we can't stay here forever."

Percy poked his head into the kitchen. "You are both up early. I see you have food and comforts. I trust that you slept peacefully."

Mary came through the other door.

"How good it is to see you, Mary," said Percy. "Tell us. Have you finally accepted Lord Byron's challenge?

Are you ready to share your ghost story with us?"

"Please, Percy. I am not worthy of Lord Byron's challenge. Again, my thoughts could not form a sentence worth writing. Lord Byron and Dr. Polidori will think me silly. I feel they will question my parents' legacy. I am afraid I've let them down but even more scared I have disappointed you."

"If you feel that way, you are foolish," said Percy. "You have written words that make me proud tenfold. This is just a spell you are in. Your head will be clearer tonight."

A faint knock came from the door. When Mary opened it, she was surprised to see Hilda.

"What brings you here at this early hour? Is Dr. Polidori okay?"

Hilda handed a large bowl over to Percy. "Eggs. The chickens have been extra generous and your sister requested they be brought here."

Claire and Mary were complete opposites. Claire was moody and wanted everyone to pay attention to

her. If all eyes weren't on her, she pouted. Mary was different. You couldn't help but like her.

"That's kind of you, Hilda. If you wait a moment, I shall tell Claire you've arrived."

"Please don't," said Hilda. "I must be getting back. A storm is on the horizon and I need to be sure the shutters are closed."

Percy peered out the window. "No sailing today, I suppose." Then his eyes lit up. "Mary, why don't we take Margaret and Jacob on a walk with us? We could explore the grounds. Perhaps let them examine the boat up close."

Mary winked at us. "I'm not sure how much that would excite them, but I suppose the fresh air would do us all good. It won't be a terribly exciting adventure but an adventure nonetheless."

"If I may be bold," said Hilda. She waited for approval to speak again. Percy motioned for her to continue. "If you are looking for an adventure, then I am able to tell you where to find the grandest one."

Jacob perked up a bit.

"Go on," said Mary.

"There are the ruins of an ancient castle that once belonged to a local baron. He is said to have performed possibly illegal and probably immoral scientific experiments there."

Percy's eyes lit up and he rubbed his hands together. "Sounds like an adventure to me!"

Hilda continued. "It is said that the baron, known as Pretorious, was an alchemist who tried to turn everyday objects into gold or incredible works of art. My father told us that he took it one step further and stole the bodies of the residents of Geneva who had perished from the plague. He tried to bring them back to life. My father said he hoped to find a cure for the horrid disease. But my mother said he was pure mad. He would have to be to work with dead bodies."

Jacob jumped up. "Let's go!"

"Furthermore," said Hilda, "some local legends say that he succeeded in animating a dead man."

"My goodness!" said Percy. "I would never have thought that possible if I didn't see Margaret bring Dr. Polidori back to life yesterday."

"At least that tale had a happy ending," said Hilda. "For I'm afraid mine does not."

Percy whispered, "Do tell!"

"It was that same dead man who carried the scientist away never to be seen again. Legend has it that the castle was set to ruin and was inhabited by faeries, goblins, and elves. All still seek to find the baron's treasures and perhaps finish his experiments."

"You've given us a splendid idea for a grand adventure, Hilda," said Mary. She turned to Percy. "Our daily walk shall be to the ruins."

"Here, here," said Percy. "An adventure that is worth sharing with Jacob and Margaret. I am certain Lord Byron will want to join us. Who knows what we shall find. If we find nothing else but a story to share with Claire and Dr. Polidori, then so be it. Let's get started!"

I took Jacob aside. "I really don't want to go. Maybe I should just say I'm not feeling well. It sounds too creepy."

"You have to go," said Jacob. "What if I go and I'm zapped back to Massachusetts. We need to stick together."

He was right. What would I do if he traveled back home and left me here?

Thirty minutes later, our journey started. Lord Byron carried a huge branch as a walking stick and led the way. I think he was happy to be away from Claire for a few hours.

We hiked higher up through a vineyard and into a dense forest. The thick clouds almost completely covered the sun. It seemed more like dusk than morning. We could easily spot the old trail and we followed it for at least a mile. I was happy that I had on my sneakers instead of the clunky shoes from 1816. No one could see them under the ridiculous dress I was forced to wear. I hiked it up a few inches

so I wouldn't trip. Mary seemed to have no trouble walking through the woods with her clothes and shoes.

If it weren't for the dim, creepy light, this would have been a great hike. Jacob and I stayed about twenty feet behind Percy and Mary. Occasionally, they looked back to make sure we were still there.

"Keep up," said Percy. He laughed. "Mary and I walk greater distances each day. It invigorates us and we have some of our finest conversations about poetry, life in England, and the wonders of the natural world all around us."

As we walked, birds chattered and we heard the leaves blowing in the breeze.

"Who were the hearty souls who braved this trail for centuries?" Mary asked loudly.

"Traders, explorers, thieves, and treasure seekers!" Percy answered.

"Yes, just like the lot of us!" Lord Byron shouted.

Jacob whispered, "Let's hope this leads us back to

Massachusetts. I keep expecting to turn a corner and see Mrs. Nelson and the library."

"Well, that doesn't look like the library up ahead," I said. We stopped and noticed large moss-covered rocks and huge bricks scattered about the forest floor a bit off the path. Beyond that, there was a flat clearing with a maze of low crumbled walls and in the center what looked like the remains of a larger ancient stone building. Rotted wooden beams leaned against the inner walls while tall grass, moss and vines covered most of what was left of the place.

"So this is the storied place of local legend!" Lord Byron cried out. "Let us go and find a lost treasure or perhaps a clue to the magic and mystery that took place here!"

We carefully made our way down from the path and spread out to explore the ruins. Jacob hopped up on one of the walls and scanned the area. "I'm looking for the Seven Dwarves or Little Red Riding Hood. Too bad I don't have any binoculars."

"Funny, Jacob. Very Funny, but I have to say, of all the crazy things we've done and seen here, this is really the creepiest," I said. "Have you noticed that the birds stopped chirping?"

He bit his lip. "And the wind stopped." He jumped off the wall. "I almost get the feeling that we're being watched."

Just then, before I could say anything else, we heard a blood-curdling scream. It was Mary! Jacob and I leaped over walls and rocks and ran in the direction of her screams. When we spotted her, she was much farther down the hillside. Percy had already arrived and helped her to her feet. Jacob and I rushed over to see what had happened.

She was terrified. Shaking. Almost in tears. Lord Byron was nearby standing over what looked like an old headstone. He rubbed it with his hand to try to clear away the grime.

Jacob pointed slightly to the left of him. "Look at all of those headstones."

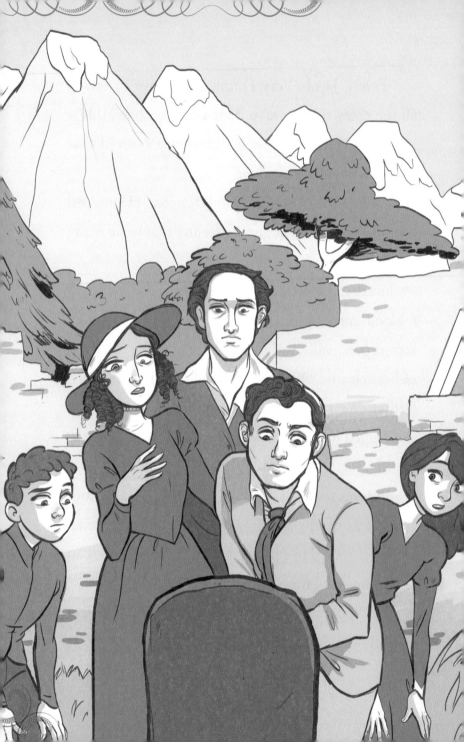

Several more headstones, some toppled, and some half sunk into the ground, dotted the landscape.

Mary steadied herself and struggled to catch her breath. Percy dabbed her forehead with his handkerchief.

She gathered her composure. "My goodness! I tripped over a rock, or a branch and tumbled through the brush. When I raised my head, I was face to face with a grave. I saw several ancient headstones and monuments to the dead. So many thoughts raced through my mind. Are these the final resting places of those poor souls who were already dead and then became unwilling victims of the mad Baron Pretorious?"

Jacob nudged me and whispered, "Pretorious is the name of a character in *The Bride of Frankenstein.*"

"Instead of investigating further, my mind raced with thoughts of terror and fear. The silence of the grove petrified me. Then a ruffling sound arose from the dead leaves and vines. Was something rising

from them? It scared me so. I turned to flee. Then something grabbed the end of my coat! It pulled me down. I am almost certain it was the bony hand of a corpse reaching up through the ground to grab me."

Jacob gasped.

"I screamed for help and Percy, oh, for whom I was ever so grateful to see, rescued me!"

Percy chuckled. "Her dress got caught by the tip of a fallen branch near a grave." He held up the branch which had a patch of fabric from her jacket on it. "She certainly had reason to be frightened and stirred."

Mary blushed. "I suppose my imagination got the best of me. I don't know what's wrong with my sensibilities lately." She pulled the fabric off of the branch. "To think how silly I was!"

"That would have scared me, too." said Jacob.

I acted shocked. "*You* would have been scared? I thought that only women and girls would be scared of things like this!"

Mary and I locked eyes and smiled.

MARY'S NIGHTMARE

That evening, Jacob and I didn't go to Lord Byron's house. We knew we needed time where we could talk without worrying about the others hearing us.

"You'll miss all the fun," said Percy.

Mary nodded. "All the tales of adventures. I am sure you would have been quite amused by Lord Byron's retelling of my follies today."

"It's not that we don't want to go," I said. "We need to go see how Jacob's father is doing. We miss him."

"And I am sure he misses you both as well," said Mary. "I should hope that young William would want to visit me if I should fall ill."

When we were finally alone Jacob and I sat in the study. "We have to figure out why we're here and more importantly, how to get back home."

"I don't know, Maggie," Jacob said. "What do you think happened? Did we fall through some sort of time tunnel? Was it something one of us said?"

I stared at the fire. "I'm not sure. Maybe we're in another dimension." I started to get teary-eyed. "We may never get home if we can't figure out why we're here. What we have to change."

We spent the next few hours trying to make sense of what had happened.

"Maybe we should tell Mary," said Jacob. "And the others."

"I don't think that's a good idea," I said. "As much as I want to, we shouldn't. What if they think we're just two crazy kids and throw us out? Then we'd have no food. No shelter. And, as much as I hate them, these clothes to wear. And if we tell them, it would definitely change history forever. You know we can't do that. That would be disastrous. We would *never* get back to Massachusetts."

There was a soft knock at the door. It was Mary.

"You're home early," I said.

"After spending four hours listening to tales that were written just last night from Percy, Lord Byron and even Dr. Polidori, I felt inferior. I am the only one who has not produced a single word for Lord Byron's challenge. I excused myself and told them I planned on writing through the evening tonight." She yawned. "Percy will stay there this evening with Claire so I will not be disturbed." She stoked the fire. "I trust your visit found your father in a healthier state, Jacob?"

"Yes," he said. "Thank you."

"Very good," said Mary. "Before I retire for the evening, do plan on sailing lessons again tomorrow if the weather is ripe. I had such fun last time. It raised my spirits."

"Can't wait," I said. "Good luck with your story."

When she left, the house was quiet once again and despite the wind outside, it was fairly warm.

Jacob and I talked for several more hours. When

the clock struck four, I yawned. "Maybe we should try to sleep for a few hours."

Just then, we heard a door open and close upstairs. Light footsteps came down the steps. I raised my finger to my lips and motioned to Jacob to be quiet. "Maybe it's William's nursemaid."

We looked over to the arched entrance of the room to see Mary standing in the doorway in a long white nightdress. Her eyes were wide-open and her hair was messy. Her complexion was so pale that it made her look spooky. She looked terrified. The light from the fireplace made a ghostly shadow behind her on the wall. Even though she appeared to be looking at us, she didn't say anything.

"Mary," I said softly. "Are you okay?"

She stood staring at the fire. Her eyes were fixated on the hearth. She stared for what seemed like minutes and appeared to barely breathe. Finally, she swung her head almost like a bird in my direction and seemed to snap out of a deep trance.

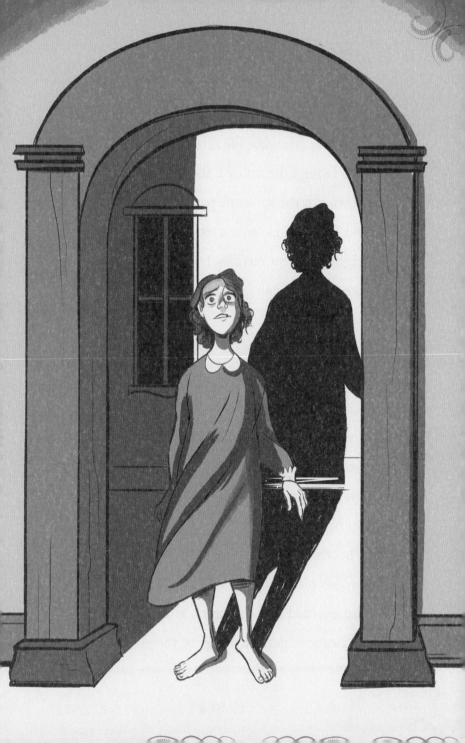

Jacob and I helped her to the couch. She swallowed hard and smiled uneasily as she gripped our hands.

"My dear friends," she said breathlessly. "I believe I awoke from a dream or I should say a nightmare. I *think* I was awake for some part of it. My imagination showed me images one after another that have left me frightened. So terribly frightened." She covered her face with her hands and shook her head from side to side.

"I saw an image of a man. I believe he was a student of the unhallowed arts. Could it have been Dr. Pretorious kneeling beside a living corpse that he had constructed? This *thing* had water flowing from his eyes and mouth. It began to stir with an uneasy motion and awakened the creator. Its creator, upon seeing the living corpse, was so repulsed and horrified that the thing he created stared at him with pale yellow-green skin and piercing speculative eyes."

She covered her own eyes and rocked back and forth. "I cannot get the image of those eyes out of my

head. It was so real that I felt the creature's breath on my face. The smell was putrid." She trembled. "It was all so real."

Mary looked petrified. I had an uneasy feeling.

"Mary," I said. "With all that has happened here in the past day or so, the storms, the ghost tales, the walk to the ruined castle, and of course Dr. Polidori's accident, you had a nightmare."

Mary steadied herself. "I have had nightmares in the past, but nothing like this. For the first time in my life, I dread to return to sleep. I am afraid that I will never be able to rest my head comfortably on my pillow again in fear that my dream will reoccur. Just the thought is too much to bear."

She stared into the fire and wiped away her tears.

Jacob patted her back. "I once had a dream that scared me so much that I had to sleep with my parents for a week."

When I smiled at him, he said, "It was a long time ago. I think I was in kinder . . . five or six years old."

Mary continued to rock back and forth. "Did you ever have the same dream again? The one that frightened you so?"

"Nah. It was right after I saw the mov . . ."

I cut him off. I spent half the time worrying that Jacob was going to blab something he shouldn't and the other half worrying about finding a way home.

"That is all well and good for you," said Mary, "but I simply fear sleep tonight. I don't think I will get the images out of my mind today although I will do my best." As she rose, she let out a slight giggle. "You will think me mad for what I'm about to say. But in some ways, as hideous as the creature was, a thrill of excitement has run through me."

A soft cry filled the room.

"Ah, William! Perhaps his sweet face is just what I need to see to help me forget the horrid vision of my dreams." She turned to us. "Thank you for listening and not laughing at my thoughts. I am hoping William offers me similar comfort."

When Mary left, Jacob scratched his head. "Some dream, huh? She scared *me* to death. I'd need to sleep with the lights on for the rest of my life if I had a dream like that."

"Could all of this be a dream?" I wondered aloud. "We have to think hard. Why? Why are we here? There has to be a catch or there has to be something that we have to do or *fix* or prove to have happened. That's how things always work in time travel and science fiction."

"What else do you know about her?" asked Jacob. "Is there anything that we have to change here in Switzerland? Maybe it has nothing to do with Mary. Maybe it's this county."

I closed my eyes. No, it had to be Mary. Something about Mary. I thought back to my honors English class last year and tried to remember something, anything, that my teacher, Mrs. Benson, had told us about Mary Shelley and *Frankenstein*. As I sat there, I began to remember what I had learned.

"Before we read *Frankenstein,* Mrs. Benson mentioned how unique it was for a woman to write and publish a novel at the time. She told us that many of the ideas writers used in their books came from their personal lives. She said Mary was the perfect example."

Jacob's eyes lit up. "Dr. Polidori! He almost drowned and then you brought him back to life! Isn't that kind of what happens with Dr. Frankenstein in the novel? I mean, he brings a dead thing to life!"

"Yep. I was thinking the same thing. But I'm trying to think what else Mrs. Benson said."

Neither one of us said anything for a few minutes.

"Well?" Jacob finally said. "What else?"

"I got it!" I said. "Mrs. Benson said that when Mary suffered from writer's block, she seriously thought of giving up writing forever."

"She told us that, too, Maggie."

I felt like I was on to something. "And it was *Frankenstein* that woke up the writer in her.

Frankenstein was the result of breaking through her writer's block!"

Jacob's eyes widened, "Mary said she couldn't write now. Didn't she say something like 'I cannot put paper to pen?' So she's definitely struggling with it."

I nodded. "She seems frustrated by the others. She thinks they're better writers. It's making her too scared to write. Maybe she needs our help to get over her writer's block. Maybe she needs ideas from us?"

Jacob frowned. "That could take forever."

"No," I said. "It won't. Because she already has the idea. She just doesn't know it yet. We need to get her to realize it so she can start her story. *Today.* The sooner she starts it, the sooner we can go home. I think so anyway." I felt a sense of relief come over me. Like I finally solved a puzzle. "But not just any story. She has to write *your* favorite story of all time. *Frankenstein.*"

A BREAKTHROUGH

We were still in the library when Mary came back a few hours later. She looked troubled and uneasy.

"Have you been up this whole time?" she asked. "No rest at all?"

"We slept a little. What about you?" I asked. "Were you able to sleep?"

She shuddered and sighed. "As I said earlier, I so fear restful sleep shall never come to me again. The visions that I saw are stealing away and hiding in my mind. They wait for me to close my eyes so they can bring chaos on my soul. Maybe sailing on the waters of Lake Geneva today will help me ease my tensions and erase my memories of last night."

"We were just talking about sailing," said Jacob.

"We can't wait to take you out again."

"I hope we can venture out today if the weather agrees," said Mary. "I do so want to surprise the men with my new skills as soon as you confirm I am ready. If I cannot please them with my writing, then I shall please them with my sailing."

"Ready for what?" asked Percy as he came into the study. He kissed Mary. "It is good to see your beautiful face once again. I missed you so last night. I had to watch Claire make a spectacle of herself over and over again as she tried to get Lord Byron's attention. It would have amused you so."

She touched his cheek. "I was just saying that I was ready for the day to begin. A new day ensures new adventures." Then she sucked in her breath. "I wish Claire would realize that Lord Byron has many female acquaintances. He will most certainly grow weary of Claire's follies. He promises her his affection then he shows her none. She waits around for him to speak to her. She is like a loyal dog that sits and waits

for its master and obeys his every word. I pity her. I really do."

Percy yawned. "Lord Byron has been honest with her." Then he added, "Most of the time. She knows of his intent. If she is fine to be a pawn in his game, then we shall continue to say nothing. I suspect when summer is over and we leave Switzerland, then she will be forced to say farewell to him."

"But we shall continue to see him since we have become kindred spirits," said Mary. "So I am sure where we are, Claire will follow. Even if it is not to Lord Byron's liking."

Percy nodded. "Enough about silly Claire. So tell me Mary. Did you write your ghost story last night?"

She hung her head low. Once again, she stood up and her troubled look returned. "The words are still absent from my mind. I have tried. Night after night I pray my words will flow but they failed me once more. Lord Byron will be so disappointed. And if I am to be pure and honest, I must confess that I didn't

have time to even think about writing last night. For I was suffering after a gruesome dream." She grabbed Percy's hand. "I had never felt so frightened before in my life."

This was my chance. "Mary, your tales of the nightmare that you shared with us this morning *were* frightening. Maybe . . ."

Mary interrupted me. "Stop! Please! I cannot burden myself to think of such horror at this moment! It is too much for my mind to bear."

Both Jacob and I gently put our arms on her shoulder.

"Mary," I said, "It's alright to share your dreams, why not tell us more?"

"Because they were simply terrifying," she said. "Simply too scary to repeat to Percy or anyone else for that matter."

"I believe you," I said. "You sounded desperate last night. When you spoke, a chill ran down my spine. I believed every word you said. So . . ."

"Out with it," she said. "What are you trying to say to me?"

"Your *nightmare* is your story for the challenge. You need to write that story down on paper. Today. Now. If your dream scared you so much, think how terrifying it will be to others. That is what you must write."

Jacob spoke softly. "The way you told it to us made me want to cry. I'm afraid that *I'll* never be able to sleep again. I'm worried that I'll see that monster in my head."

"A mark of a gifted storyteller!" said Percy.

Mary sat there for a long time without saying a word. She chewed on her thumbnail before a look of determination came over her face.

Percy looked from Mary, to me, to Jacob, and his eyes landed on Mary again. "Well?"

Finally, a look of relief came over her and she smiled. Her eyes twinkled and her face brightened. "Genius!" she said. "Simply genius! If what you say is true, then I shall do it. I don't know why I didn't

think of it myself." She jumped up and down and twirled around the room. "I feel that such a burden has been lifted from my heart and hands. I shall write again!" she shouted. Then she turned to look at us with mock sinister eyes and let out a laugh. "Perhaps I will find the peace of mind when I unleash the gods and monsters from my nightmare upon the waking world! Yes indeed. I certainly shall write again. Today, I shall write again!"

Percy took her hands in his. "Before you disappear into your writing room, please tell me about the dream. What was it that scared you so?"

"No, I cannot tell you. I won't tell you." She laughed. "At least not yet. You must wait to read my words on paper tonight! Lord Byron will be pleased, and hopefully, most impressed. Perhaps he will be terrified with the tale I will weave today."

Mary hugged and kissed each of us then rushed off to write. It was as if she were struck by a bolt of some creative lightning and came to life herself.

When we were alone, Jacob looked out to the lake and saw sailboats gliding in the distance. The mountains covered in the ever-present fog that seemed like it was never going to lift.

Jacob plopped onto the couch. "So I guess we're not taking her sailing today?"

"Or any other day if we can get home," I said. "I think this might work. We've been hoping that our time here would end by itself or maybe there would be some entrance or portal that we would fall into."

"Or reopen," said Jacob.

"But after seeing the way Mary reacted when she realized she finally had a story to write convinced me that we *were* sent back here to help her break through her writer's block and write *Frankenstein*."

"Are you sure?" Jacob asked.

But I didn't have to answer. Nature answered for me as a huge gust of wind blew open the shutters and scattered Mary's untouched writing paper throughout the room.

FRANKENSTEIN IS BORN

Mary kept her promise. Throughout the day, she was nowhere to be found.

"Do you think she took your advice?" Jacob asked as he skipped a stone across the water.

"She better have," I said. "Or we'll *never* get home."

The weather was the best it had been since we arrived so we took advantage of it. We spent time in the boathouse playing cards and Dominos and then took the boat out on the lake. But without any life jackets, we didn't stay out too long. We saw Percy and Lord Byron taking their daily hike without Mary. They were heading off in the direction of Geneva. Lord Byron had two of his dogs with him.

"Mary's not with them. Maybe that's a good sign," Jacob said. "I hope so anyway."

"It's funny," I said. "This is the one morning that looks like we're not going to have a storm. It would have been a perfect day to give her another sailing lesson. But don't get me wrong, I'm thrilled Mary's finally writing again. I just hope she's a fast writer."

We sat on the dock and dipped our feet into the water.

"Are you going to miss this place?" asked Jacob. "I mean, if we get home today like you think we will."

"Yeah, I am," I said. "But I'm dying to get home. Now." I thought of all the cool things that had happened since we arrived. "I still can't believe we've gone back in time to Switzerland in 1816. It's neat that we ended up living with famous people, isn't it? We got lucky. There's been plenty of food and despite the lousy weather, seeing the lake and the Alps was amazing. Even the servants were nice to us. Plus we got to tour those creepy castle ruins. What if we went back in time to the middle ages or landed in a war? Now *that* would be scary."

"Just as scary as Mary's crazy dreams," said Jacob. "Could you imagine if they knew who we were and where we came from? I wonder if they would have believed us?"

"They would," I said. "Let's face it. If they believe that reanimation can really happen, then I think they'd believe anything. Even time travel. I can hear them now. Mary would say, 'Time travel? Fascinating! Simply fascinating! Do tell!' Percy would say something like, 'What a marvelous opportunity to go back in time and change the course of history. Perhaps we could derail the intentions of the tyrants.'"

"That really sounds like them," said Jacob. "You nailed it."

"And Lord Byron," I said, "would probably say something like, 'Traversing through the ages! What wonderment! What possibilities to see the future and to revisit the past. Magnificent! To share my genius with others like me in the future and in the past makes my heart sing out with glee.'"

"Too funny," said Jacob. "But Lord Byron would make crazy hand gestures as he said it." He made sweeping motions with his arms. "What about Claire?"

"That's easy. She wouldn't say anything. She doesn't hear a word anyone says unless it comes from Lord Byron's mouth," I said.

"True," said Jacob. "But if she did, it would probably be something like this." He used a high-pitched voice. 'I'll travel anywhere as long as it's with Lord Byron.'"

Then he made a bunch of kissy faces which made me laugh hysterically for some reason. It was easier to let loose and laugh now that I was pretty sure we would get back home.

When we got back to Maison Chapuis, Percy was already dressed for dinner.

"Mary hasn't been seen at all. I can only assume she is writing away each hour as if it were her last on Earth. I slipped a note under her door telling her that

we shall go ahead to Villa Diodati. She can meet up with us if she is able." He looked us up and down. "It seems like you both had a jolly time today. I am confident you will dress for dinner now."

We nodded.

"I shall be ready to go as soon as I see sweet William. I trust you will be ready to join me then?"

Once we were dressed in proper clothes, we went to join Percy outside.

"I'm starting to like this velvet coat," Jacob said. "If we do go home, I wonder if it could come with me as a souvenir?"

"Not me," I said. "These clothes are itchy and way too frilly for me. I can't wait to ditch them."

We walked with Percy through the vineyard to the villa. The fog and low clouds were settling down from the mountains. The late day sun was fading and the entire lakeside looked gloomy at this time of day.

"Percy?" I said. "Do you really think Mary has been writing all day?"

"I do," said Percy. "Mary has been writing with the intensity of one of the Furies. Her mind is busied with an idea that has broken her frustration. Even if Mary does not join us tonight, the good Dr. Polidori, much recuperated from his episode, has crafted quite a wonderfully frightful treat for us! He himself has written a lurid tale of a mad nobleman who steals away by day in a castle and, after bitten by a bat, ventures out into the night. He haunts local villages looking to drink the blood of his fellow humans! It is quite chilling."

Jacob poked me in the arm and whispered, "Maggie that sounds a lot like a vampire story. Maybe even *Dracula*!"

"It might be," I whispered back. "I think it was written around the same time. But I don't think that Dr. Polidori was the author of that story."

As we continued walking, I noticed the sweet smell of flowers as we came out of the vineyard and entered the garden. As we walked up the path to the

villa, we saw Lord Byron sitting on the porch with one of his dogs on his lap. Two peacocks strutted nearby.

"Ah! Greetings my fine, noble friends! And how are you all faring this evening?" Then he cocked his head. "And what of Mary? Where is that gentle flower?"

Percy gestured back to Maison Chapuis. "Mary has kept herself behind her door throughout this fine day, putting pen to paper. She has crafted an idea for a story, a ghastly story, to make us shiver with fright! We shall let her be for now. Perhaps she will join us at a later hour."

"Staggering stars!" said Lord Byron. "That is grand news! We shall await her story with eagerness and bated breath. But come upstairs, my friends. Hilda has prepared a fine feast for us: roast goose with wild berries and cooked vegetables. Dr. Polidori awaits us with more dispatches from his story."

Jacob scrunched his nose. "Goose?"

I rubbed my stomach. "I'm ready for some of my mom's lasagna."

Jacob licked his lips. "I think I miss my dad's French toast the most."

"Cross your fingers," I said. "Let's hope we have French toast and lasagna tomorrow."

Before dinner started, Dr. Polidori entered the room.

"It is wonderful to see you again, Dr. Polidori," I said.

"It is wonderful to be seen again," he replied. "I must thank you, Margaret, for I heard you had the healing hands. If Lord Byron did not tell me himself, I never would have thought it possible. But I am grateful for the life you breathed back into me."

Lord Byron chuckled. "So grateful that he finally spoke to Hilda about his wound."

Dr. Polidori blushed. "Mary was correct. Hilda was able to soothe my ills. I had been stubborn far too long in resisting her wisdom."

After finishing our dinner, we took our places around the fireplace on the other side of the room.

Dr. Polidori shared his story that he called *The Vampire*. We sat quietly listening to the doctor describe his creepy tale. It sounded like it could be a movie or a popular television series now. Other than the sound of the fire cracking and the wind stirring up the trees outside, it was eerily quiet until we heard the faint sound of footsteps coming up the stairs.

Then all of a sudden, the two doors of the salon burst open and Mary rushed in. She was wet from the rain and hadn't bothered to put on her dinner clothes.

Dr. Polidori stopped reading.

Percy rushed over to her, "Mary, my dear, are you alright?"

She triumphantly held up a thick journal like a trophy. Though she was out of breath, she quickly gained her composure.

Thunder rumbled in the distance and a gust of wind rattled the shutters.

"Cross your fingers," I said. "This could be it."

"My dear friends and acquaintances," Mary said calmly. "I have overcome the torments that have deprived me of my writing abilities. I have begun to write a tale. A tale that has been rolling about the deep recesses of my mind and has now broken through and consumed me."

"Bravo," said Percy as he kissed her cheek. "I had every confidence that you would emerge with a great tale."

Mary laughed. "I do so hope you find it that way. My hands ache but now my heart is ever so light."

Lord Byron raised his glass. "Alas! You have accepted my challenge and now we must hear the wicked words you have put to paper. Do share and delight us all with your tale."

Mary blushed. "I was eager to prove myself to you, Lord Byron, but felt I was not worthy of the challenge at the time. As you know, my words failed me when I needed them most. But today, they poured out from

my hands and my soul. But I must thank Margaret and Jacob for stoking the fires of my abilities. Without them, I fear I would never have introduced all of you this evening to Dr. Frankenstein and his monster."

A boom of thunder echoed across the lake and made Claire jump out of her seat.

"She did it," whispered Jacob. "You were right, Maggie. She did need our help to write the book."

I spoke up. "Mary, the words and ideas were all yours. You scared us so much with your dream of the monster that we knew it would make a great story. I am excited to hear you read it."

"But without you both," said Mary, "my story would still be locked away inside my conscious for I was too afraid to let it out." Then she held out the journal toward me. "To show my gratitude, I would be honored if you both would read my story first. It is only the first thirty pages but I am confident the foundation is set and I cannot wait to return to my writing tonight."

"You want *us* to read it first?" said Jacob. "Really? Are you sure?"

"Quite," said Mary. "And to show my appreciation, please note the name . . ."

But she never finished her sentence. Because as soon as Jacob touched the journal, a blinding flash of light filled the room. Then the candles and the fire flickered on and off before being snuffed out for good. We were in complete darkness. I felt woozy. Dizzy. So dizzy, that I fell to the ground. A whoosh of cold wind rushed over us. Then, oddly, the sound of Mrs. Nelson's voice boomed above us.

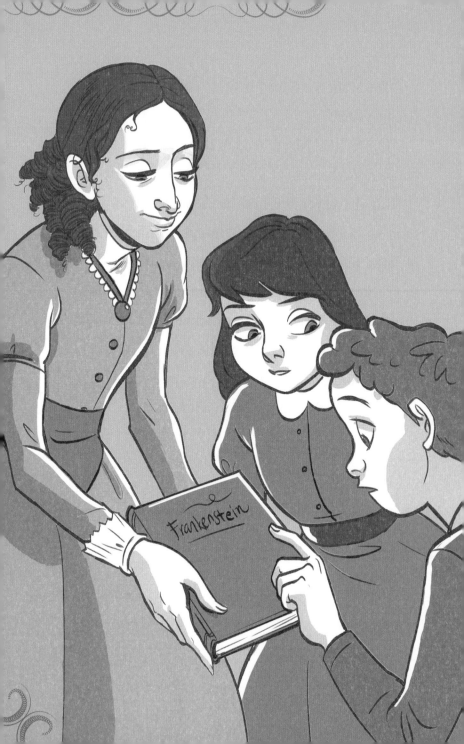

A NEW ARRIVAL

"Jacob! Are you here?" I groaned. "Where are we?" I stood up and looked around the dark room. "We better be in the Jonathan Bourne Public Library."

"I'm right here," he said. "On the floor."

For a second, Jacob's voice sounded far away. But once I shook my head and my ears popped, everything became clearer. "I see bookshelves."

"And books that need to be repaired," Jacob whispered.

I flicked on a light switch. "Does this mean? Are we . . . ?"

Jacob jumped to his feet. "Yep! We're back in Bourne, Massachusetts."

We high fived each other.

"We did it, Maggie! We made it back to the present. You were right. Getting Mary to write *Frankenstein* brought us back." Then he narrowed his eyes and crossed his fingers.

"What's wrong?" I asked.

"I just want to make sure I wasn't knocked out and had some crazy dream," he said. "Did we really . . ."

"Travel back in time to Switzerland in 1816 and meet Mary Shelley, Percy Shelley, Lord Byron and all the others? Yep. If you were dreaming, then I had the same dream."

Jacob looked relieved. "Okay, so it wasn't a dream. It really happened! It's good to know that I'm not crazy." He glanced around the room. "How long do you think we were gone? Days? Weeks? Years?" His voice cracked. "What are we going to find when we go back upstairs?" He pointed to the copy of *Frankenstein* that I had shown him. "Do you think it's okay to touch it?" He leaned over the book. "What if I do and we get zapped back in time again?"

"I'm not sure," I said. "But I don't want to touch it."

"I don't either," he said. Then he grabbed a broomstick and poked it. Nothing happened. I said, "I think it should be fine as long as you learned your lesson."

Jacob looked confused. "What lesson?"

I put my hands on my hips and smiled. "Who wrote *Frankenstein*?"

Jacob looked relieved. "Mary Shelly. All by herself. I'm positive of that." Then his eyes lit up. "Actually, all by herself *after* we helped her break through her writer's block."

Then we stood there quietly for a minute to take it all in.

"What do you think she meant," I said. "When she said, 'And to show my appreciation, please note the name.'"

Jacob paused before finally snatching up the book. When nothing happened, we sighed with relief.

He thumbed through the pages. "I see the names Dr. Frankenstein, Elizabeth . . ." Then a smile spread over his face. "I found it! Remember when the story starts off with Captain Walton picking up Victor Frankenstein off the ice in the arctic?"

I nodded. "Because the monster chased Dr. Frankenstein and he was trying to get away from him."

"And Dr. Frankenstein tells his story to Captain Walton before he dies. Do you remember how the story starts and ends with letters written between Captain Walton and his sister?"

I nodded again.

"Well, guess what his sister's name is?"

I thought about it for a minute. "I can't remember. I know she was from England but I can't remember her name. What is it?"

Jacob raised his eyebrows. "Margaret Saville!"

"No way!" I said. "She used my first name and your last name. Do you really think it's because of us?"

"Who else would it be . . . *Margaret?*"

I rolled my eyes and laughed. "You mean, Maggie, don't you?"

"Are you two okay down there?" came Mrs. Nelson's voice as she clomped down the stairs. "I've been calling but you haven't answered. Didn't you hear me?" She glanced at her watch. "You've been down here a long time."

I stuttered. "How long?"

"At least ten minutes. How long does it take to find a book?"

Jacob pumped his fist in the air. "It's only been ten minutes, Maggie. Only ten minutes!"

Mrs. Nelson noticed the book in Jacob's hand. "So was it helpful, Maggie? Did you see what you needed to see?"

"Yep, Mrs. Nelson. I did. And Jacob learned *a lot* from this book. Trust me."

"Oh, that's nice. I do love when you kids read the classics and come away smarter for it." She put her

arm around Jacob's shoulder. "So tell me, what did you learn?"

Jacob took a deep breath. "I learned that not only did a woman write *Frankenstein*, but that a woman can write a scary story just as well as a man."

"And?" I asked.

"A woman can do *anything* just as good as a man," he said.

Mrs. Nelson looked puzzled. "How old are you, Jacob?"

"Twelve. Almost thirteen."

"And you're *just* learning that now?" she said.

"Better late than never," he answered.

I heard a loud rumble that sounded a lot like thunder and I jumped. I expected to see Lord Byron, Percy or Mary coming down the stairs.

"Yikes!" Jacob said, startled. "Is that thunder? Is there a storm blowing down through the Alps?"

"Alps?" Mrs. Nelson looked at Jacob with an odd smile. "You do have quite an active imagination.

That's not thunder at all. We have some workers upstairs moving a new bookcase around."

"I don't ever want to hear the sound of thunder again," I said.

After putting *Frankenstein* back on the repair cart, we followed Mrs. Nelson upstairs. Jacob and I were surprised to see his parents waiting for him by the circulation desk. Mrs. Saville patted her stomach.

"There you are," she said. "It's time. My contractions are ten minutes apart."

"Wow!" said Jacob. "I can't believe the baby's coming today!" He looked at me. "I'm so glad I didn't miss this."

His mom continued to rub her belly. "What I can't believe is that we still don't have a name picked out for her yet." She turned to me. "We want a classic name. Something that is simple yet signifies a strong female. I wanted Sarah."

Jacob's dad smiled. "Sarah Saville sounds too movie-starish. I wanted Danielle."

Now Jacob's mom smiled. "Danielle Saville has way too many *L*s in it. So, Jacob, we are desperate. We can't have this baby coming into this world without a name. Have any ideas? And don't give us any wild names like Apple or Bear or Blue. We want simple. Classic. Classy."

It only took Jacob a few seconds before he had his answer.

"Mary," he said. "Mary Saville would be a perfect name."

"Mary Saville," repeated his mother. "Mary Saville." She bit her lip and whispered, "Mary Saville" once again. "I like it!" she said. "No, I *love* it! It's perfect."

"Ding, ding, ding," said Jacob's father. "We have a winner. Mary Saville it is."

Mrs. Saville grimaced. "I think we better get going. I can already tell Mary is going to be a force to be reckoned with. I think she's ready to make her appearance *now*."

Jacob grabbed his backpack. "Let's do our project on Marie Curie tomorrow. I've heard of her but really don't know anything about her. Sound good?"

"Sounds great," I said. "Let me know when the baby's born."

He paused. "Want to come to the hospital with us?"

I shook my head. "No thanks. I'm going to ask my mom to take me to the mall. I need to buy a baby gift."

Jacob smiled. "What are you going to get her? We have a million bibs already."

I shrugged my shoulders. "I don't know."

But the truth was, I did know what I was going to get baby Mary.

I had the perfect gift in mind.

A pen.